The

DRONE

PILOT'S

HANDBOOK

An Hachette UK Company
www.hachette.co.uk

First published in the UK in 2016 by ILEX,
a division of Octopus Publishing Group Ltd
Carmelite House
50 Victoriat Embankment
London, EC4Y 0DZ
www.octopusbooks.co.uk

Distributed in the US by Hachette Book Group
1290 Avenue of the Americas
4th and 5th Floors
New York, NY 10020

Distributed in Canada by
Canadian Manda Group
664 Annete St., Toronto, Ontario
Canada M6S 2C8

Publisher: Roly Allen
Associate Publisher: Adam Juniper
Managing Specialist Editor: Frank Gallaugher
Senior Project Editor: Natalia Price-Cabrera
Editor: Rachel Silverlight
Art Director: Julie Weir
Designer: Anders Hanson
Senior Production Manager: Peter Hunt

ISBN 978-1-78157-298-6

A CIP catalogue record for this book
is available from the British Library

Printed in China

······· ADAM JUNIPER ·······

The

DRONE
PILOT'S
HANDBOOK

The KNOWLEDGE **The SKILLS** **The RULES**

ilex

CONTENTS

4 **Missions** **92**

5 **Safety Card** **118**

6 **Photography Elective 140**

INTRODUCTION

Something very unusual happened to a sheep on the 19th of September 1783. It found itself stood next to a duck and a rooster suspended in midair. From this historic vantage point, the wooly quadruped could look out across a crowd of 130,000 men and women, including King Louis XVI & Marie Antoinette, all staring up in wonder at it, and (more significantly) the hot air balloon that carried it aloft.

This was the Montgolfier brother's balloon, and only once the sheep, called Montauciel, had returned to earth having survived its ordeal, would humans would risk a turn.

A century and a bit after the first men took to the skies, Orville and Wilbur Wright took their famous first flight at Kitty Hawk. Their airplane—a wooden frame that amounted to little more than a motorized kite—represented the first time we took to the skies under our own control, but yet in under 70 years a human footprint was pressed into the surface of the moon.

That incredible pace of development might seem to have disappeared, but really it's just been democratized; right now you can join the new pioneers of flight wherever drones are sold.

Drones are exciting; an altogether new category of device that has emerged from nowhere in half a decade to offer a new outlet for speed freaks, photographers and filmmakers alike.

At the same time farmers, anthropologists and utility companies have all found a new way to collect crucial data, and emergency services new speedy solutions. Oh, and one day they might deliver packages too.

Sadly, though, that doesn't seem to be quite the message the media has got across. Well, except for the package delivery. Instead we hear a lot about the dangers: "Near miss with passenger jet" and "drone crashes into stadium crowd" and very little about the positives.

The problem? In a word, idiots.

Well, that and the entire structure of the profit-hungry modern media with its emphasis on deep psychological fear and decades of real-terms decline in journalism and editorial investment.

One of those we can fix (hint: it's not the second one!).

The aim of this book is to give drone pilots the understanding they need to freely take to the skies without doing anything idiotic.

It's important, too. Drones are pretty new to the world and it wouldn't take too many mishaps for legislators to decide that, on balance, it'd be better to ban them all.

That would be a terrible shame for such an exciting developing technology with the potential to make life better, and one that is so much fun.

That's what this book is for: to show you how to be a droner.

For updates, reviews, tutorials, and videos, visit www.tamesky.com/handbook.

GROUND SCHOOL

WHERE DO DRONES COME FROM?

When a mummy drone & a daddy drone love each other...

Actually while some might joke that drones seem to be the result of an unholy marriage between a radio-controlled car and an especially angry hornet, they're not as far from the truth as all that.

Obviously, the heritage of radio-controlled cars, boats, planes, and especially helicopters has played its part, but the real innovation comes courtesy of the Nintendo Wii and generation of iPhone-inspired phones, both of which vastly reduced the size and price of the kind of sensors multicopters need to detect their position, direction, and inclination.

Hobbyists were putting these pieces together from the moment the first one unscrewed a Nintendo Wii remote (MultiWii is still a common drone control system), then in 2010 French company Parrot caught the public imagination with a consumer drone, the AR.Drone.

ARE THEY LEGAL?

Yes, drones are legal. Stupidity, less so.

Later in this book the chapter "Safety Card" will go into more depth on this area, but don't let some media excitement confuse you; the kind of drones you can buy and fly are perfectly legal (more than can be said for some of the things governments do with their military drones).

In most countries, including the US and UK, flying drones for fun is governed by sensible light-touch rules designed to keep you out of other people's airspace (below 400ft) and away from buildings, roads or people you don't know. Freedom isn't free, so in the US you'll also be required to register your drone at https://www.faa.gov/uas/registration/ (for about the price of a coffee).

In addition, of course, the whole law still applies; including civil liability, meaning that if you cause damage with your aircraft you'll be liable. The worst-case scenario here is causing a multi-vehicle wreck by flying over a highway, which could run into millions or even earn you a second-degree murder (manslaughter) charge. Civil liability insurance will cover you, but only while you fly within the rules—the road definitely wouldn't count.

Commercial uses, like wedding photography, are a different matter. Different countries have different rules, which can include the requirement of passing a test at your own cost. More details can be found in the "Safety Card" chapter.

SO, IS IT A DRONE, OR...?

Why do people call drones so many things?

There is a fair bit of confusion about what does and does not count as a drone. The best technical definition is probably small "Unmanned Aerial Vehicles" or UAVs, but that's a bit cold, which is no doubt why it hasn't caught on.

Inside the flying community, though, the media's use of the word "drone" remains controversial. Some don't like it because of its association with military craft like the Predator and Reaper (hardly named to give a warm and fuzzy feeling). Others note that, like a bee, drones will simply get on with business on their own, whereas most craft are piloted remotely rather than performing tasks autonomously.

As with any hobby, there are some who take this discussion well beyond the point it makes any sense to do so. You've got to have something to do while the batteries are charging, I suppose. For this book I'm going to stick with "drone," or— where a bit of variety is needed—"multicopter." I hope no one minds too much.

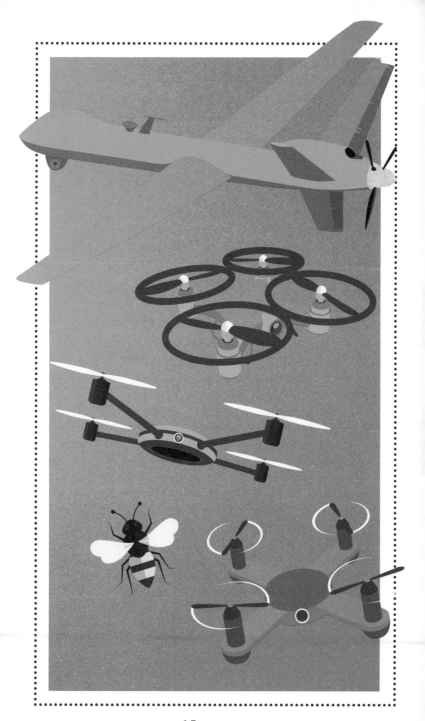

INDOOR FLIERS

··

Why go outside?

It's horrible outside, or dark, or you just don't like it. Since the postman (or, if you're reading in the future, delivery drone) will bring new toys to your door, why face it?

There is a wide range of drones designed to be similarly agoraphobic, and when shaping a craft not to have to face the perils of the wind, designers can afford to dial up the fun. Motors, props, and the craft itself can be tiny, and remote-control systems can be one of any number of light, established, domestic technologies like infrared (like your TV remote) or bluetooth.

Of course any drone can fly indoors, but the larger it is the smaller the building seems. To mitigate this, some manufacturers provide a protective indoor hull—a frame that protects the propellers—and/or so-called "optical flow" sensors (see page 90), which help avoid drift when near the ground.

TOY DRONES

Fun is our profession!

Toy stores sell drones, so they must all be toys, right? Well, no. But they can be. Toy status is more a matter of what you do with it (and some people will call it a toy whatever).

Nonetheless, it's fair to say there is a hard-to-define category of drones built for the sheer joy of flying more than anything, and a "drones" category has appeared in most gift and gadget-store catalogs in recent years.

Though you might expect to find cheap knock-offs of the more established brands, there is also a lot of innovation in this category, and designers have incorporated more creative ways to protect the props (or people from the props) than many prosumer and professional multicopters, at considerably lower prices.

Just as indoor drones, be prepared for more gadget-and-tech inspired control systems, like Wi-Fi from your smartphone, alongside traditional long-range radio controllers.

250 CLASS

Built for speed

Compact and powerful, the 250 class is named for the diagonal measurement between opposite motor spindles in millimeters. If you haven't already, getting into drones means accepting metric into your life. Citizens of the British Empire circa 1800 and anyone else who hasn't updated their ruler—I'm looking at you America, Liberia, and Myanmar—would think of 250mm as 9.84 inches.

Multicopters like these are built for FPV (first-person video) racing, in which a camera is strapped onto the frame and the pilot flies from the picture it transmits back, often using special video goggles.

It requires skill (and skill comes from trial and error), so there's a well-established Fly, Crash, Repair, Repeat cycle that will keep your mini-screwdrivers busy. Luckily, the frames are tough and the cheap props usually take most of the blows. Don't leave home without your repair kit!

FLYING CAMERAS

The photographer's coolest accessory

It didn't take photographers long to realize the possibilities of aerial photography; the ability to capture images or video from an altogether different perspective is incredibly exciting.

Getting up in the air has a few downsides from the traditional photographer's perspective, not least the vibrations caused by even the most perfectly balanced of motors and propellers. Photographers and moviemakers also need to be able to position and line up their shots.

The "flying camera" class of drones, then, are those that feature a motorized gimbal—a device to electronically steady a camera usually hung below the airframe—a monitor to allow the pilot to see through the camera remotely, and probably GPS, to keep the drone in position as still photos are taken.

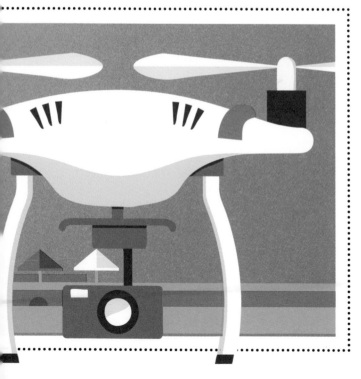

PROSUMER DRONES

You get what you pay for (sort of)

As soon as the category of "flying cameras" had established itself, sub-categories were bound to emerge. After all, the cheapest DSLR costs a fraction of what the high-end professional models do, yet many enthusiast photographers go for the pro models; they're just as easy to use in their basic modes, but offer more opportunity to go off-piste with manual settings.

With truly professional drones typically having more in common with kit-builds—allowing flexibility but requiring specialist knowledge—there was a gap in the market for an off-the-shelf solution that offered key pro features, like dual-operator mode, in which one pilot flies the craft while another takes control of the camera.

Needless to say, several manufactures have provided premium-quality aircraft for exactly this market, offering aircraft that are ideal for a photography or videography business expanding its horizons.

TOP PROFESSIONAL

The sky's the limit (in every sense)

Potentially costing truly eye-watering amounts of money, professionals can specify drones to their exact needs, or build them themselves from components sourced from the same companies that ship thousands of ready-to-fly drones to the consumer market. As a result, don't expect beautiful design in this category, but practical, modular construction.

Professional requirements include the ability to hold aloft Hollywood-grade cameras, and by that I don't mean "it's 4K," I mean vastly expensive and heavy lenses with the ability to be remotely focused for real aerial cinematography.

Other applications, such as police monitoring and search and rescue, require longer flight times.

Heavier payloads and flight time both require more battery weight, so some professional UAVs seem pretty monstrous in size, anything from 2kg to 20kg take-off weight.

HOW IT TURNS

Leonardo da Vinci didn't get it

In his famous sketch of a possible flying machine, Da Vinci didn't take into account the centripetal force that would turn the platform as well as the wing, so even if the four men turning cranks were somehow able to lift their own weight, they might have found the experience nauseating, brief, and ending very abruptly.

Because of the force, all that's needed to turn the craft left is for the flight control computer to speed up the rotors that spin clockwise (the opposite direction), and slow down the other rotors proportionally, so the lift remains the same, but the imbalance in the centripetal force turns the craft on its axis.

As a pilot, this process is handled automatically. If your controller is set to the standard "Mode 2" (see page 34) moving the left stick left or right will rotate (or yaw) the aircraft.

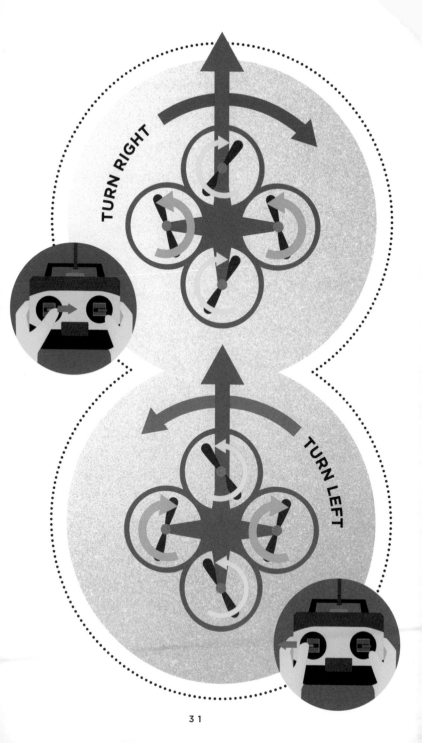

TURN RIGHT

TURN LEFT

TRICOPTERS: RULE BREAKERS

Every rule needs an exception

There is one common kind of multicopter that doesn't use math to defeat centripetal force, or, more accurately, doesn't do it with the number of propellers. Instead, the tricopter uses a servo motor to tilt the back rotor as necessary.

Tricopter fans say that the three-propped craft is smoother and more exciting to fly; that makes it a popular, if ambitious, self-build project for many—an ideal next step if you've built your own quad. The smoothness is great if you've got a camera strapped to the hub too.

Just as with other multicopters, the pilot steers by moving the left stick horizontally (Mode 2), but in addition the flight control computer handles the yaw servo, and the result is an aircraft that can bank, pitch, and yaw like an airplane, but hover like any other multicopter.

CONTROLLERS

Be in mode

The pilot's controllers typically feature two sticks, each able to move along two axes. These are the first four "channels" in old-school terminology, but they don't always work the same way.

By far and away, the most common arrangement outside Asia is Mode 2, which effectively turns the right stick into the main control stick on a helicopter, with the left stick handling rudder (rotation) and throttle.

Mode is especially important if you're buying an RC with an un-sprung throttle stick (which can be left high or low), since the controller will be physically different for Mode 1 (and 3) from Mode 2 (and 4).

CAUTION

This is not about being left-handed or right-handed; pilot preference is key.

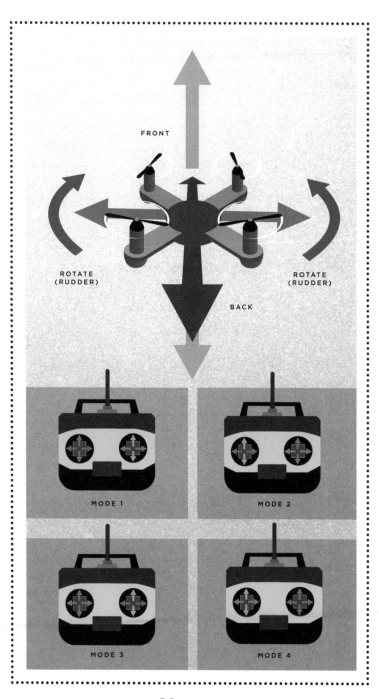

FRONT

ROTATE
(RUDDER)

ROTATE
(RUDDER)

BACK

MODE 1

MODE 2

MODE 3

MODE 4

HOW IT FLIES

Much the same way bricks don't

Although the spinning props and palpable downdraft give away a little more about their means of staying aloft than a Vogon starship, multicopters seem to hold their position almost magically; they don't just fall over sideways or spin out of control.

That's because subtle changes in motor speed are being made many thousands of times a second by the flight controller— the computer that makes multicopters possible—all without the pilot needing to take individual control of the motors. Flight controllers correct for any imbalance as soon as it is detected, and with more sophisticated systems, can even prevent the drone being pushed away from its GPS location by the wind.

To stop the copter spinning around out of control, the propellers are arranged in pairs, which turn in opposite directions; these cancel each other's torque, meaning there's no need for a tail rotor as on a traditional helicopter.

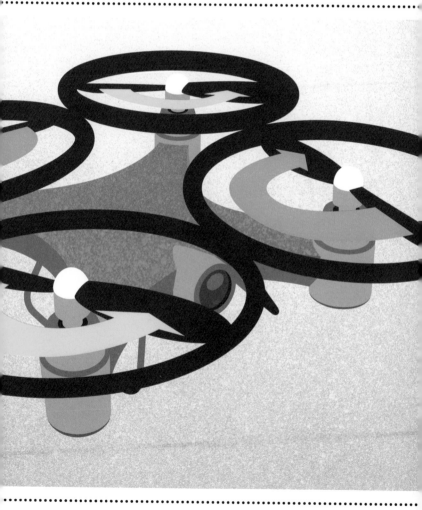

LINE OF SIGHT

How far can you see?

Although many drones come with sophisticated FPV systems able to relay video directly back to the pilot, the rule generally is: if you can't actually see the drone, you can't fly it.

The conventionally accepted distance that you can still see your craft with enough detail to judge its position in 3D space is 500 meters, about five-and-a-half football fields.

As you watch your drone move away from you, assuming entirely level flight, the copter will appear to be sinking as perspective puts it nearer the horizon; this—alongside the direction the drone is facing—is something you'll need to get used to.

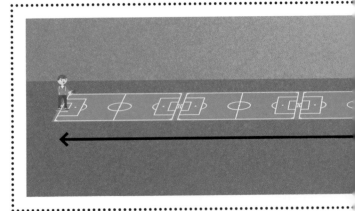

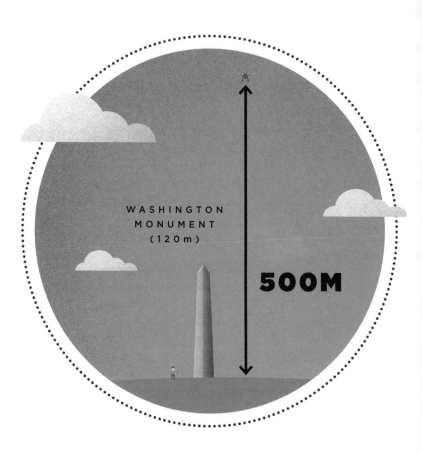

WASHINGTON
MONUMENT
(120m)

500M

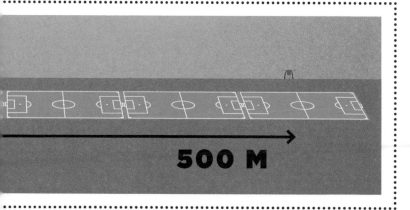

500 M

TELEMETRY

··

It's all in the numbers

Drones couldn't fly without their on-board flight controller computers, and in turn, it sucks in data from a range of devices, including air-pressure sensors for altitude, accelerometers for speed and direction, and sometimes GPS for position.

Sharing this with the pilot via the control system requires a two-way RC system, and these have become more common as the importance of drones to controller manufacturers has increased, and digital systems have made better use of the available bandwidth.

At the enthusiast end, telemetry displays are either included in RC controllers, bolted on as after-market kits or a device is added on the drone to feed the telemetry into the video signal. At the buy-and-fly end, the data might be added into a digital signal and displayed by an app.

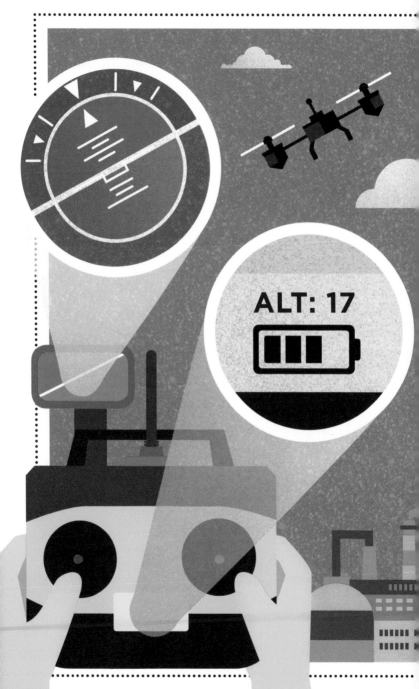

FIRST-PERSON VIEW (FPV)

First-person view, but no shooter

The video game industry is not wrong; the action feels fantastic if you can see straight out of the pilot's seat (or from the eyes of a soldier facing the enemy in hordes.)

Surprisingly low-tech in this age of digital HDTV, a tiny PAL/NTSC camera is placed on the front of the drone and a transmitter sends the signal straight to the pilot's receiver, usually worn on the head.

Analog might sound historic to the modern tech enthusiast, but it has much lower latency; digital signals need to be encoded and decoded, all valuable milliseconds during which a pilot needs to avoid crashing.

CAUTION

Obviously, an FPV pilot can't see all the dangers around them, so you should always have a friend as a "spotter."

PILOTING SKILLS

SIMULATORS

If you only crash pixels, you never lose cash

Fortune does not favor the brave.
If anything, the fortune is on its way to the brave's favorite parts supplier. You can at least nudge things in your favor by using a flight simulator to get to grips with the very basics of how the sticks work.

There are several choices, from smartphone apps to desktop computer apps. Some of these require sophisticated RC controllers; others will work with a PlayStation controller. DJI even includes a simulator mode in its Pilot app (Inspire 1, Phantom 3, and later).

The more stick-like the controller you use with your chosen simulator, the more useful it will be as an experience, and it's important to make sure you're simulating the same controller mode you'll be flying in.

FLIGHT MODES

Sporty or solid

Many cars offer a "sport mode," which will slightly alter handling characteristics (and start guzzling down the gas). The mode switch on a drone can have much more dramatic effects by switching on or off certain pilot-assisting technologies.

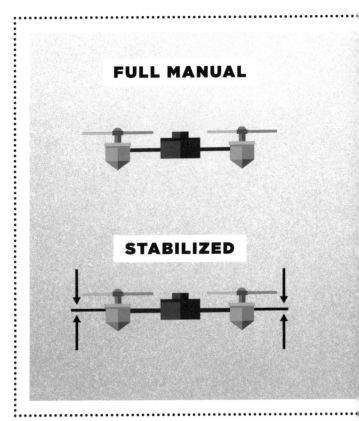

FULL MANUAL

STABILIZED

The effects vary from manufacturer to manufacturer, and drone to drone, but essentially they are:

- **Full Manual:** Experienced pilots only!
- **Stabilized:** Remains level.
- **Altitude Hold:** Remains at the same altitude when you release the sticks, but will drift like a hockey puck.
- **Loiter/GPS Hold:** Remains in the same position in 3D space when you release (center) the control sticks.

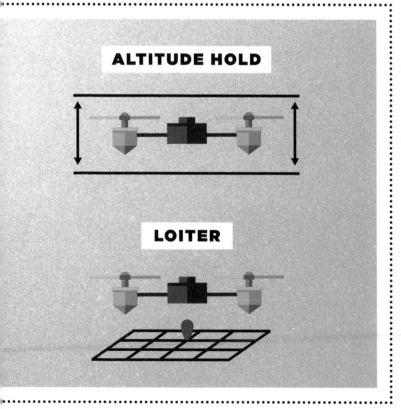

ALTITUDE HOLD

LOITER

EASY MODES

Absolutely relative

As well as flight characteristics, new drones are also offering something called variously "absolute" control mode, "super-simple mode," and "headless mode."

In normal mode, if you take off, fly forward, rotate left 90 degrees (rudder), then fly forward again, the drone will move along the new heading (left from your perspective as a pilot).

In easy mode, however, if you were to take off and make the same left turn, the forward control would still send the drone away from your position.

The advantage is that you don't have to worry about the orientation of the drone; handy when it's hard to see, or simply when thinking in 3D is a bit much!

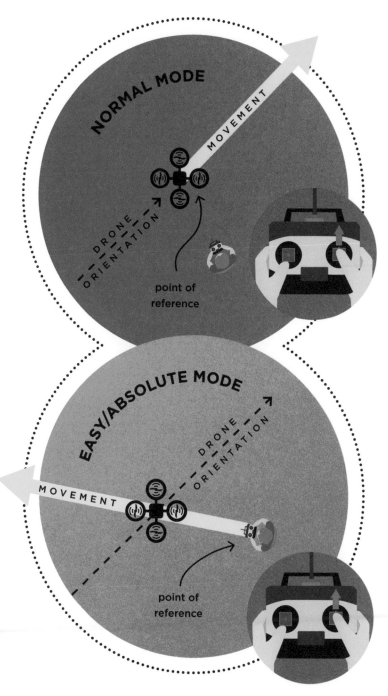

NORMAL MODE

MOVEMENT

DRONE ORIENTATION

point of
reference

EASY/ABSOLUTE MODE

DRONE ORIENTATION

MOVEMENT

point of
reference

HOME PRE-FLIGHT

Do your homework

Do you remember that dream where you showed up at school naked? No. No one else does either.* It's just a lazy writer's shorthand to invoke concerns about preparedness, and prep is how you avoid looking and feeling like an idiot when you show up with something that won't fly.

The most common mistake is to show up with dead batteries (or charged batteries for the drone and dead ones in the controller). Whenever there's a good weather forecast, check the status of your batteries.

The night before is also the best time to check all the screws—the vibrations of flight can loosen them surprisingly fast—that you have enough props in your bag and any tools you need. Finally, check your memory cards aren't full, and then make sure they are in the bag.

*If you do remember it, check it wasn't real...

BATTERY FACTS

Chemical firelighters

You might think the reassuring plastic packages that wrap Lithium polymer batteries are no different from the cells that power your flashlight, but in truth there's a lot more power wrapped up in these high-tech modern batteries, and with great power comes great responsibility.

Some out-of-the-box batteries include sophisticated power-management tools, which can check the charge and will even automatically

discharge to a safe level if the battery isn't used for a time (another reason for that pre-flight check).

The "home-brew" crowd is more familiar with wrapped battery cells with a positive and neutral power connector and a smaller cable with a thread for each cell inside the battery.

In either case, batteries have a limited chemical life; as they age or are damaged they will puff up and lose their shape. At this point—usually about 200 flights—it's time to replace them.

LOCATION PRE-FLIGHT

Preparing the way

When you arrive where you want to fly, begin by making sure the location is safe (refer to Chapter 5: Safety Card); people, bad weather, and nearby airports should all be reasons to stop you in your tracks.

As you attach the props, make sure they're all damage-free and that you're attaching the correct props to the correct motors.

Next, you need to be sure there's no radio interference. Lots of Wi-Fi will cause problems for most drones. You should also position your antenna for the best possible signal—that doesn't mean point the end at the copter, but to the side of it.

Find a flat surface with about 6m/20ft of room around it (taking off on an angle can confuse the system's idea of what is level) on which to place the drone, and put the drone down with its front pointing away from you, then step back yourself.

ARMING & DISARMING

Careful, the safety is off

Although your average multicopter doesn't have the obvious lethal potential of a firearm, an accidental swipe from a rapidly spinning propeller shouldn't be high on your experiential wish list either.

For that reason, powering up the drone is usually a three-part process; firstly, you'll need to make sure the switches on your controller are in their standard positions then switch your controller on—always turn it on first in case you need to take charge.

Secondly, plug in the battery on the copter and (if there is a switch) turn it on, before placing it on the surface that'll serve as a launch pad and stepping back.

Now, finally, after one last glance around, you are ready to arm the drone; this is usually simply achieved by briefly pushing both sticks to one corner or the other; the props will begin turning gently.

TAKE OFF

··

What goes up...

Once your drone is armed, lifting off
is a matter of pushing the throttle up until the
props are turning fast enough to show gravity
who's boss.

More sophisticated flight controllers will try and
place this at just over 50 percent, so that anything
above the center position on the control stick
increases altitude and anything below decreases
it; a useful behavior especially for inexperienced
pilots, and one pilots of flying-camera-type
drones have come to rely on.

As soon as you're off the ground you're subject
to everything the air can throw at you, so you
need to have your hands on the sticks; that said,
unless you have a ground sensor (optical flow or
sonar), it's a good idea to get a few feet off the
ground, above the ground turbulence, before
attempting to slow your climb and take control.

Extra height also buys you vital moments to
correct for errors.

P I L O T I N G S K I L L S

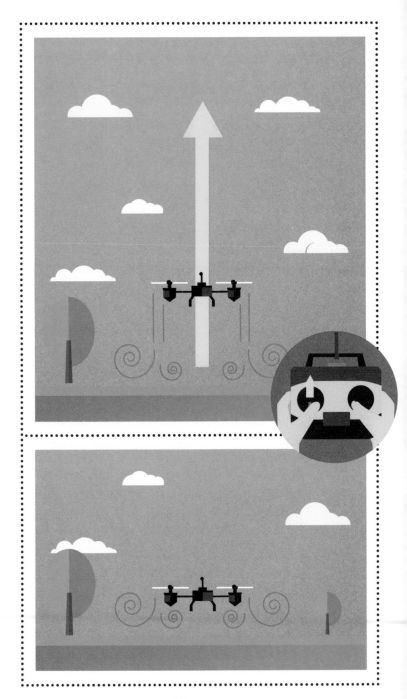

MAINTAINING POSITION

∙∙∙

Should I stay or should I go?

The more manual your mode, the more difficult hovering is, but it's important to get the hang of it before you start flying. There's nothing more reassuring than knowing you can keep your drone in the air before you start to have some fun with it.

Most flight modes work in such a way that the middle position on the throttle stick is the point at which the drone hovers; push up to climb and down to land.

Some learner pilots like to practice this without the risk of drone-loss by using a tether; you'll need to ensure the lead is attached to the bottom of the drone so as not to get in the way of the props, and be heavy enough so that it hangs below the drone. It is a great way of getting up and practicing hovering in one spot.

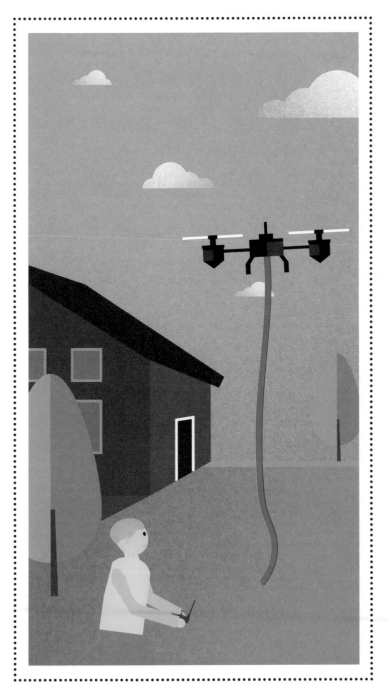

TWO-DIMENSIONAL THINKING

..

Won't beat Captain Kirk

It didn't do Khan any favors, but assuming you're not under attack and you've mastered hovering and maintaining flight, you should begin traveling around using what is, in the standard Mode 2, right-stick flying.

The right stick sends the drone forward or backward (elevator on an old-school controller) or charging left or right like a crab (aileron) in the same direction as the stick.

This leaves the "front" of the drone pointing the same way it was when you took off, a little like "Easy Mode," and allows you to move the craft around your position.

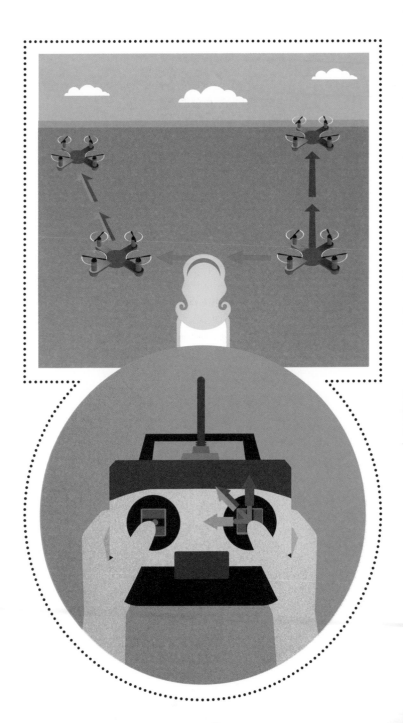

CIRCLE

Like the windmills in your mind

The horizontal control on the left stick (in Mode 2) takes the place of the rudder on a traditional model plane, which turns the drone around its central axis.

In other words, this is the point you'll have to use your brain for flying; you'll need to appreciate that a device under your command might be facing toward you, or away from you, or any position in between.

The best way to practice this in a controlled way is to practice flying forward and turning at the same time, trying to keep the turns consistent.

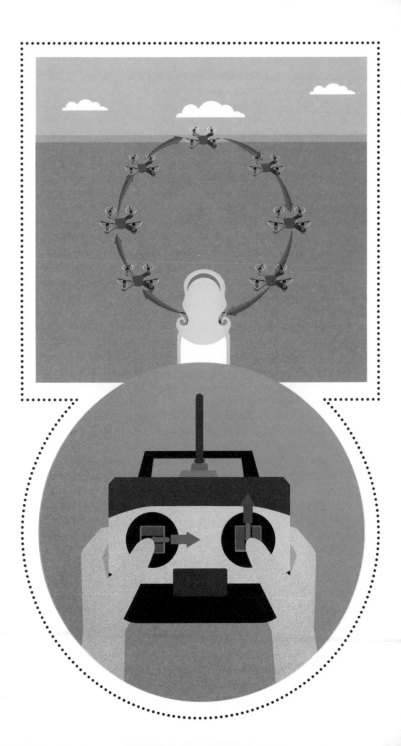

FIGURE OF EIGHT

··

Circle plus!

Once you've completed some turns while maintaining altitude, all you need to do is mix things up a little. The (horizontal) figure of eight doesn't sound much harder than circles, but doing it accurately is more taxing.

Pick two points on the ground and fly around them in a figure of eight. Start slowly at first and pick your speed up. The constant repetition of this exercise will help you accurately go into and come out of turns without overshooting, and really helps with thinking from the drone's perspective rather than yours, since it will alternate between facing you and facing away from you.

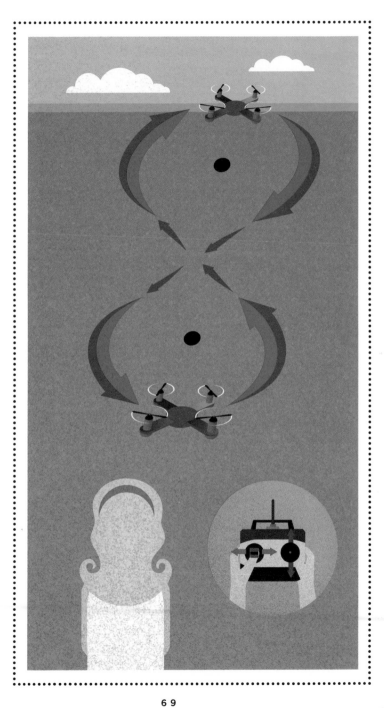

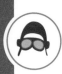

ORBIT

Videographer's favorite

Similar to the circle, but this time pick a point or object and rotate around it while keeping the front of the drone—typically where the camera would point in a single-operator drone—pointed at the object.

That means combining the rotate (rudder, mode 2 left-stick horizontal) and sideways (aileron, mode 2 right-stick horizontal) so that the amount you're traveling with the craft is exactly countered by the amount you're rotating. If you apply the rudder too hard you'll spin in small circles and still drift off in the same direction, while if the directional "roll" control is too strong, the drone will arc away like a decaying orbit. Only the perfect balance will give you an orbital circle.

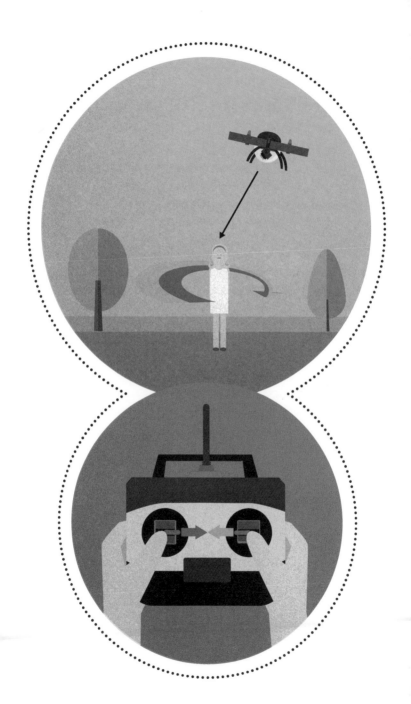

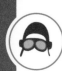

FLIP

Be top gun

There are drones that will flip for you with a button on the remote. That looks cool, but it won't make you top gun. There are others that simply wouldn't survive the experience; you wouldn't do a stunt with a passenger jet.

But if you've gone for a sporty little number, why not try giving it a flip. All you need to do is blast the throttle hard to give yourself a bit of altitude, then cut it right off. As the drone reaches the summit of its ascent and starts to fall back, push it sideways with a sharp movement of the right stick.

When the drone is about halfway over, flip the right stick back, power the throttle up again and take control again.

Best to practice over grass rather than concrete!

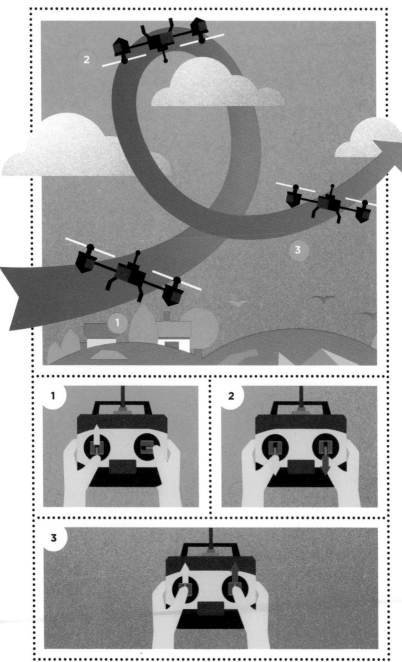

IN THE HANGAR

CENTER OF GRAVITY

Even weight, even flight

Whether you're building your own drone or "modding" one, it's essential that you make sure its center of gravity is, well, the center (the point around which the props are arranged).

If the weight isn't evenly distributed, one of the motors will have to do more work to maintain level flight. Even a very minor imbalance can be enough to wear the motor or ESP out, risking crashing mid-flight.

Since the biggest weight on board is likely to be the battery (and possibly the camera), the best solution is to keep the battery near the center—back a little if you need to balance a camera—and hung below the props.

FREQUENCIES

Kenneth knows, for sure

Just like television, radio or cellular telephones, Radio Control (RC) and First-person Perspective Video (FPV) require a portion of the radio frequency spectrum to operate.

Radio Controllers (the signal to the drone) typically use 2.4 GHz, the same as Wi-Fi b/g/n, with all the same frequency-hopping cleverness that ensures that (so long as there aren't too many competing devices) numerous signals can coexist and keep out of each others' way.

Analog FPV systems can use a variety of signals, most commonly 1.3 GHz, 2.4 GHz or 5.8 GHz (higher frequencies travel less distance, but need the smallest antennas). The potential for overlap with 2.4 GHz is obvious, but there is a finite number of channels within the other bands, so there are only so many pilots who can fly safely at any one time. An infinite number of people can watch one broadcasting drone though, so anyone can watch the pilot by tuning their monitor/goggles in.

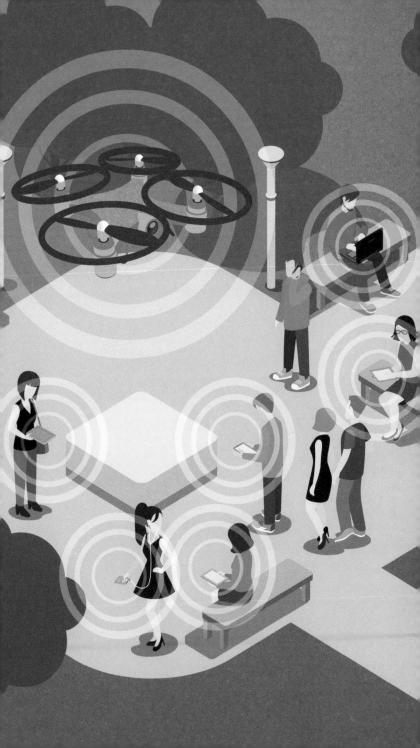

PROP(ELLOR)S

Slicing the air

Longstanding RC enthusiasts won't fail to bring up "propeller balancing" before long, it's worth knowing about it. According to some gruff racers it's a complete waste of time, while others say it's essential and impossible to fly without it. The truth, as always, lies somewhere in between.

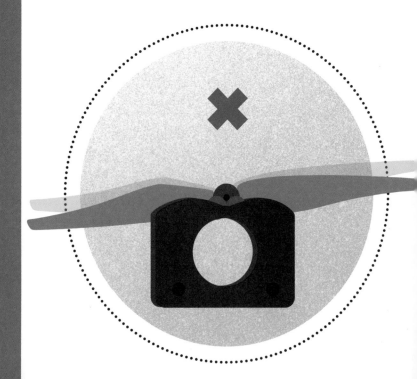

Prop balancing is a way of making sure the weight of both propeller blades is evenly distributed to minimize vibrations: good for all drones, vital for photos. This is achieved by adding a little bit of weight to the lighter end, usually in the form of Scotch tape.

To find out how well your propellers are balanced, remove them and place them in a prop-balancing tool. These tools are cheap and use magnets to hold the propeller frictionlessly. Hold it level and release. If you need to take corrective action, make sure you apply a small piece of tape to the back of the propeller blade, not the side that pushes the drone aloft, otherwise the airflow will be uneven.

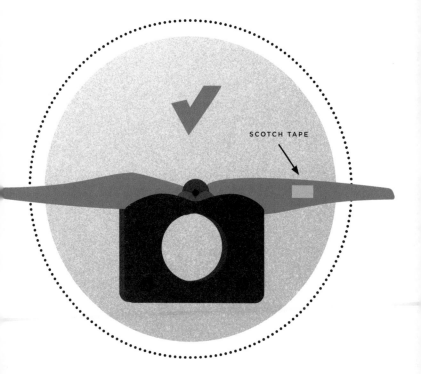

SCOTCH TAPE

PROP GUARDS

Health & safety gone sane

If you're flying indoors, or simply getting used to a new drone, then wouldn't it be great if the nasty, sharp, pointy, fast-moving blades weren't the furthest things from the center? The part of the drone most likely to touch anything you should accidentally brush against in flight?

The solution is a prop guard, which can be retrofitted inexpensively to many popular drone designs, or even supplied with some.

The reason guards aren't added to all drones is a matter of weight and sail area; outdoors, they can catch the wind and make your drone more likely to fly away. In low wind and indoors that isn't such a risk.

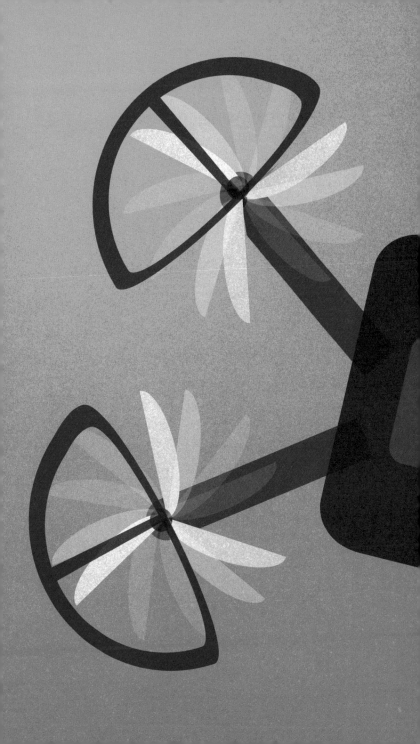

TRIM

IN THE HANGAR

Don't be caught up in the drift

Even the most modest of "toy" drones is likely to have some additional buttons on the remote that move in parallel with the control sticks.

These trim controllers allow you to correct the sideways drift caused by wind or not-entirely perfect sensors. The principle is very simple: if the drone drifts to the left, tap or move the horizontal trim controller beneath the right stick in the opposite direction until the drone stops drifting.

More sophisticated RC controllers might place the trim control in the menus. With more advanced drones, you may be able to adjust the trim in the flight control software.

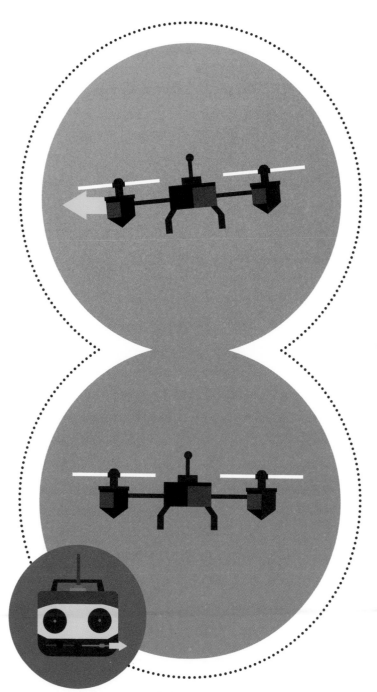

GIMBALS

The tripod of the skies

There are two solutions to supporting cameras on drones: to strap them to the main frame and hope the vibrations are low enough so that the video is watchable, or to use a motorized gimbal to correct for the drone's vibrations and—as a bonus—sharp movements.

Gimbals work by using two (pan up and down and roll) or three motors (adding pan left or right) to counter vibrations and the angle that the drone leans. The third motor is typically used to soften out a sudden turn left or right for smoother-looking footage.

As a bonus you can usually control the motions of the camera remotely, especially on the up/down pan, via an extra controller on the remote.

Gimbals are very finely balanced devices, usually specifically built for a certain camera; the bigger the camera, the pricier they get. Owners of unusual cameras beware, popular devices like the GoPro are well supported.

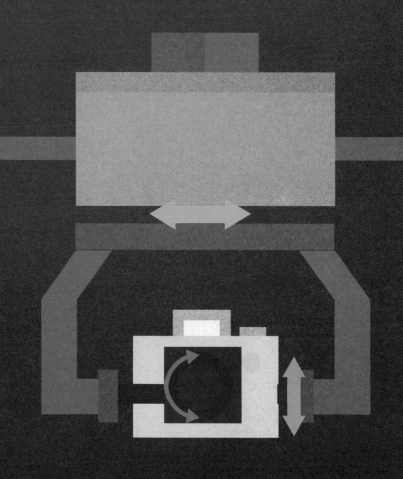

YAW

ROLL

PITCH

GAIN & EXPO

Engine tuning

A multicopter drone stays in the air by constantly adjusting the speed of the rotors. By tweaking how frequently the drone makes these adjustments, how strong they are, and how quickly they back off making each adjustment, you can affect the characteristics of the drone in flight,

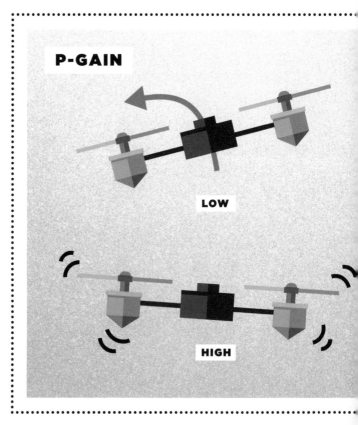

from sluggish to smooth, right up to jumpy and frankly unflyable.

This is known to engineers as PID: Proportional, Integral, Derivative. All the values are set to down, then raise P until there is vibration (low P makes the drone likely to drift, high P makes it very jumpy). Raise I until the drone shakes for over a couple of seconds at a time, then drop it a touch. Finally, bring up D to counter this effect and the copter should then be firm in the air.

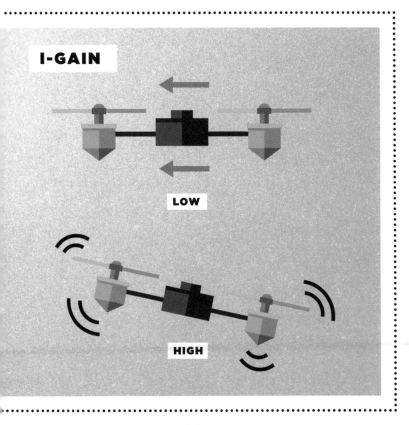

OPTICAL FLOW

Electronic eyes

They've mastered flying, photography, and following predetermined paths. Collision avoidance is the next big thing for drones, and technologies that play a part in that are already available.

Many multicopters feature downward-facing sonar devices that, within a few meters of the ground, can detect range to help maintain low altitudes without crashing (or to activate their landing gear).

Additionally, cameras watch for "optical flow"— they literally watch the ground to see if the drone is moving and, if necessary, correct it. Assuming that the ground isn't all an even shade (which would confuse the camera), this means a drone can remain still indoors just like a GPS-locked drone can avoid drifting outdoors.

These technologies are starting to be applied to drones, so in time drones should be able to keep a lookout for objects horizontally as well. Soon, the humble tree might not be such an enemy to the drone!

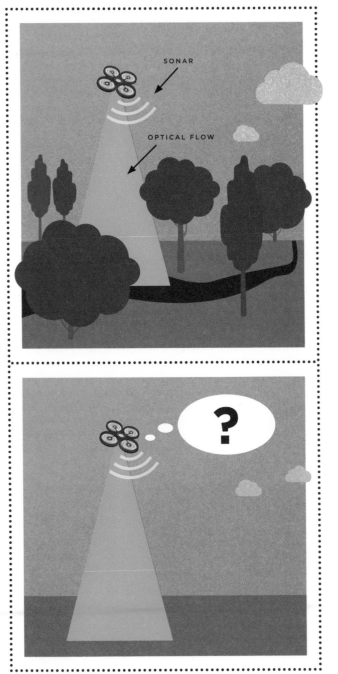

91

MISSIONS

AERIAL PHOTO

The fun side of real estate

Capturing a great aerial photo for a brochure, or just for the fun of it, obviously requires a camera on your drone. Depending on the camera, you might also need a program like Photoshop to straighten the images. The eye is a lot less forgiving of the fish-eye curves from action cameras (like the GoPro) in stills than it is in video.

For better photos, try and shoot soon after sunrise or in the last hours before sunset; the sun is lower in the sky, so the light must travel through more atmosphere, giving the light a warm, golden quality that makes everything look good.

While you're in the air, remember the rules of composition; do not get carried away. If your subject matter is a house, let it take up most of the frame. If your subject matter is the gardens, give it a bit more altitude and distance.

AERIAL VIDEO

Swooping vistas

Television and filmmakers were quick to see the advantages of aerial photography, bringing the beautiful scene-setting aerial shots within the financial reach of the average TV show or even student filmmaker.

If you're asked to provide aerial shots, make sure you know exactly what's needed. Both factual shows and fiction will require the cinematographer's staple: a wide-angle scene-setting shot to reveal the environment in which the upcoming action is about to take place. Drone movement should be slow and gentle, perhaps toward the center of the location.

Storytellers might need you to follow a subject; you should aim to do so from the same side as the non-aerial shots to make the scene flow together.

Whatever the case, make sure everyone in the area knows what you're doing, and never feel pressured by the crew into flying; you, as a pilot, have the ultimate decision on safety.

DRONIE

Who needs a selfie stick?

The @dronie Twitter feed might have settled into a rut after a first spate of enthusiasm led by Captain Picard (Patrick Stewart) himself, but the dronie is still a great way to share a selfie with a bit more perspective. In the era of instant-share video services like Vine, what could be better?

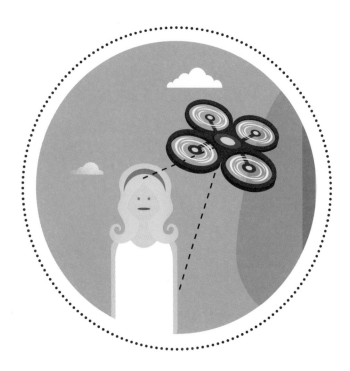

The technique is pretty simple: get airborne and turn the drone to face you. Start recording, give the camera a jaunty wave, then blast the copter back and throttle up at the same time. You'll quickly be a tiny speck in the distance.

CAUTION

Take care to fly backward; it's easy to get confused with the drone facing you.

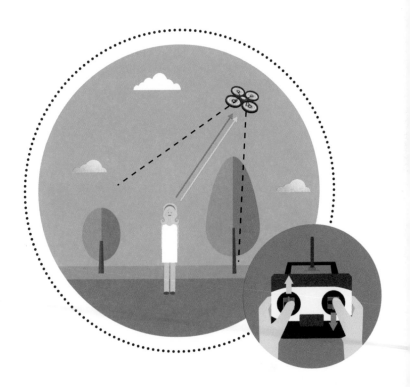

FOLLOW-ME

A robotic angel on your shoulder

Following a moving subject isn't easy; it's something you'll need to practice. Or will you? Many drones now feature a "follow-me" mode in which the GPS of your mobile phone (or a special watch) provides a target for your copter and its camera.

Follow-me is as simple as the manufacturers tell you. The main risks are getting outside of the drone's range—this is definitely more for skateboarding than race-driving—or forgetting it's following you and having too much fun. The battery is limited, after all.

Remember, too, that most drones have no collision-avoidance sensors, so start above any trees and power lines.

CAUTION

Don't drive down a public road with your drone following; it's not safe and your car is too fast.

DELIVERY

What people know about drones

Assuming that your friends don't think you'll be using your drone for remote attack missions, spying on your neighbors or bringing down passenger jets, the next thing they ask about is delivery. You can thank Jeff Bezos at Amazon for that—but at the moment all Amazon's drone program has delivered is a series of press releases just before its peak sales season.

Realistically, the amount of power required to lift even a 1kg payload and carry it a mile means that—even if you were allowed to fly unsighted— delivery by multicopter would be pretty impractical right now, but advances are being made.

Clearly, there is a future in which auto-programmed craft fly through legally cleared airspace to landing pads, but there are many obstacles still to overcome. Where they will likely be first overcome is through access to remote places like oil platforms.

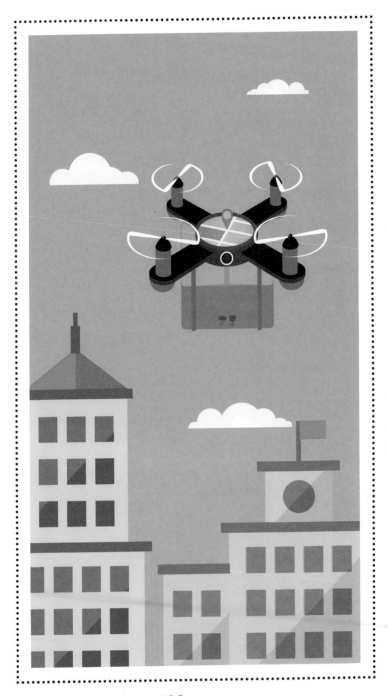

DRONE FLASH MOB

Formation flying

An aspiration for the technically minded should be to equal the achievements of Ars Electronica Futurelab from Austria. The team there built bright RGB-based LED lights and attached them to a swarm of 50 quadcopters, all controlled by a single computer.

Amongst their most famous exploits, the team's "spaxels" (space pixels) drew the Starfleet logo above the Thames in London before the release of *Star Trek Into Darkness*, a movie set in the city.

Talented programmer-choreographers have developed their own software using GPS, or using whatever is available for their chosen aircraft. Displays are increasingly common at trade shows, so check the events plan at your nearest convention center.

SET UP A RACE

Plan a fiendish aerial challenge

Racing is what transforms your drone from a fantastic hobby into a hard-nosed competitive experience, somewhere between *Top Gun* and pod racing from *Star Wars*, but how do you go about getting a track together?

What you need is big, light, portable, and safe 3D objects that can serve as gates for you to (aim to) fly through. You don't want them to be too narrow, especially at first, and they certainly shouldn't be delicate. Short of Quidditch hoops from your local magical supplies store, your best

bet is to fashion hoops using pool noodles. You can join them together for larger hoops (upside-down U shapes work best).

It's also good to mark the ground with arrow mats, which can be sourced from drone stores; these are easy to follow through FPV goggles and a big take-off mat is a very fair way to mark the start point. Camping pegs will keep the mats secure despite the draft created by passing multicopters.

Make sure that the whole course is a safe distance from any roads or buildings, and remember you won't need many hoops; most of the fun comes from pilots trying to get back on track after the monumental effort of getting through one hoop.

RUNNING A RACE

Control others' fun!

Once you've built a top-notch circuit it's time for you to entrust it to the competitors, but your job's not over—not by a long shot. You're also going to need to lay down the law so everyone flying can have a fair crack at the whip, and an agreed means of comparison with peers (a way to "know who's won" in English).

Drone enthusiasts with customized racers are not people who instinctively play by the rules. If they did, they'd spend their weekends doing the gardening and taking the trash out like they were told, instead of ripping through the skies, but with limited frequencies, control is needed.

There is a finite number of frequencies (especially true for FPV video), so when many pilots are in the same place some order will be needed, ideally in the form of a schedule that allows some time for pilots to tinker, before circuit rules kick in.

At that point everyone who isn't flying should power down, and those flying should power up and check for any interference. You could even allocate radio channels in advance. Pilots should then place their copters on a mat and take off.

It's best to stagger takeoffs, calling "Go" one at a time, with someone recording times from the first gate to the last, is probably the safest and easiest way to race, and leaves fiddly takeoffs out of the equation. You can keep having rounds until the pilots' fingers are sore and the day's best time wins.

SEARCH & RESCUE

Eye in the sky

An aerial perspective can be a huge boon when hunting for a missing person, and a UAV quadcopter is an excellent and inexpensive platform for that. They're also useful for other aerial surveillance, and have been used by the police in the UK and India, and by anti-graffiti teams on the German railways. In the US, a military-class Predator drone has even been used.

An organization exists for UAV operators to volunteer to be ready should the call ever come in. By signing up at sardrones.org, pilots agree to volunteer their services at a moment's notice to help in the hunt for a missing person.

CAUTION

Make sure the authorities want your help; never risk delaying first-responder aerial vehicles.

MAP MAKER

Building a picture from the sky

If you've ever used an image-editing program like Photoshop to combine a series of photographs into a single panorama, then you've already got the know-how you need to make your own high-resolution aerial map.

The easiest way to do it is to take advantage of any on-board flight-planning tools available to you, and fly your copter up and down over the survey area, taking pictures regularly. Some

drones can even be programmed to take pictures
when they're needed for mapping. If you don't
have this feature, remember that more pictures
is better than fewer.

Once you've got your pictures, drop the folder into
Photoshop's Photomerge tool—the "Reposition"
mode should work best.

3D MAPS

Thought the last mission was clever?

Creating an aerial image is one thing, but that's so last century. By taking more images and information about the camera's angle and position found in the hidden data recorded by the camera—called "EXIF"—you'll have enough data to create a 3D map.

The downside is that 3D mapping requires new and more powerful software tools, but there are already a couple of options out there; one is mapsmadeeasy.com, an ingenious service that allows you to collect your images with the craft of your choice, then upload them to the site for processing. Users can add new maps as layers and see progress over time—ideal for surveyors and farmers.

If you'd rather have the software installed on your own system, check out Pix4D.

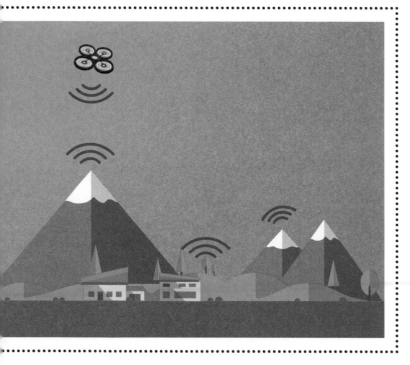

PLANNING

GPS autopilot planning & execution

What could be simpler than touching a few spots on a map and letting the drone fly from one "waypoint" to another?

Actually not a lot; using GPS to plan a route is pretty easy, but it's important to remember you're flying in 3D space, and the points you set are really invisible spheres. As soon as the drone is inside a sphere, it will move on to the next. That means you need to be sure that the altitude of each sphere is set high enough that even the bottom of it clears any trees or obstacles—power lines are very hard to spot on the digital maps most planning apps use.

Of course, you also need to maintain line of sight and be able to switch back to manual at any point, as per regulations.

CAUTION

Be sure there is enough battery power to fly your route. Your author lost a drone in the sea this way!

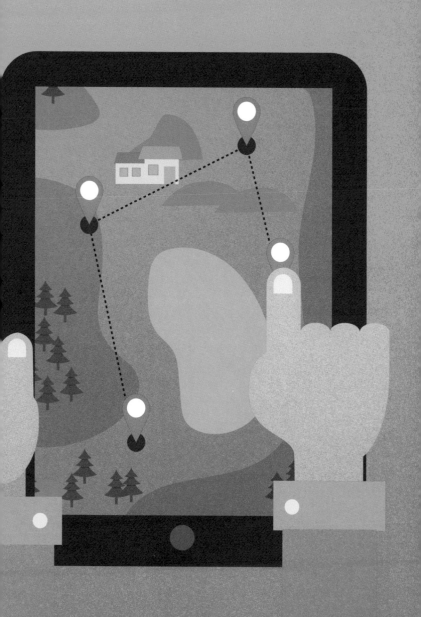

SAFETY CARD

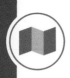

WHERE TO FLY

The distance rule

If you want to stay out of trouble, you should maintain a safe distance from obstacles and, crucially, other people who aren't part of your droning fun times.

You should keep your drone a sensible distance away from buildings, roads, wildlife, and people who aren't in your gang, and well away from built-up areas. In our diagram, we've shown the UK CAA's (Civil Aviation Authority) rule of 50 meters, but the actual distance might be different in other countries.

Additionally, some areas have absolute bans, including American National Parks and The National Trust in the UK.

ROAD

50 M

DRONE

50 M

YOU AND
YOUR BUDDY

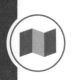

WIND

How can you work out wind conditions?

It is never safe to fly if the wind is more than half your copter's maximum speed, ideally considerably less than that since you need to allow for gusts.

An average consumer drone will have a maximum speed of 10–15 meters/second (up to 30 miles per hour), however, their quoted maximum speed will be based on flying them aggressively in manual mode; realistically, the fastest horizontal speed will likely be a bit lower.

That means a 10–15 mile-an-hour wind would be enough to slow your drone to half speed against the wind, but have it shoot away as fast as a car with the wind.

PETS

Animals love drones, but they shouldn't

A drone can do a surprising amount of damage to flesh, especially some of the custom builds with sharp carbon fiber propellers. A number of careless or unlucky users have shared some shocking images online, once they've got back from the emergency room!

Those people, however, chose to take the risk; most pets don't fully understand the danger, but they're intrigued. Dogs seem to love drones, rushing up to them barking and leaping. It can be playful fun, but if the battery power were to dip and the drone get in reach, those props will do a lot of harm.

Moreover, even if you are personally ambivalent to the pains of pets, remember that most people don't see things that way. Animal charities do better than those for starving children, after all.

BIRD STRIKE

Not one of the flock

Though it swoops and it soars with the best of them, your drone isn't a bird, and contact represents a bit of a problem for both parties. Worse still, birds are far from scared of even pretty big copters.

SAFETY CARD

126

One might suppose that a creature of the sky, dependent on its wings, might choose to give the whirring unnatural monster that passes its way some room. However, birds, especially larger ones like seagulls, will come uncomfortably close to a drone.

Whether they believe your multicopter is their god or an enemy to be herded away, you're at risk; a plastic prop hitting a bird will not only hurt the innocent animal, but likely stop turning long enough for the drone to be lost (especially a 3- or 4-prop craft). Worse still, props turn with enough power and force to break an eagle's wing, so it's not just a mechanical life that's at risk here.

If you see birds taking an interest in your drone, back off and come back later.

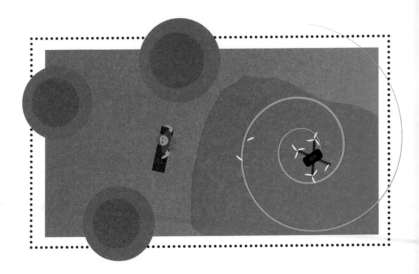

JET STRIKE

People keep asking, so, well...

One of the nightmare scenarios the media loves is the risk of a multicopter being sucked into an aircraft engine with devastating consequences. Drone manufacturers have done much to mitigate this risk; many drones won't even take off if they detect they're near an airport. But would it really matter?

When a new jet engine is designed, it's tested with both huge lumps of "hail" and a number of birds. Engines have no problem slicing through birds up to about 3kg (6.6lbs), more than most drones, and the hail lumps are more solid than even the battery. A jet can survive 700kg (1500lbs) of hail in 30 seconds. Engineers we have spoken to seem to think the average drone would simply be spat out the back and the jet would keep on flying.

If the worst does happen, the nacelle that houses the engine is built to absorb the shock of the engine, throwing a blade and destroying itself; and unlike Captain "Sully" Sullenberger's plane that fell to a flock of large birds, the pilot would still have at least one engine.

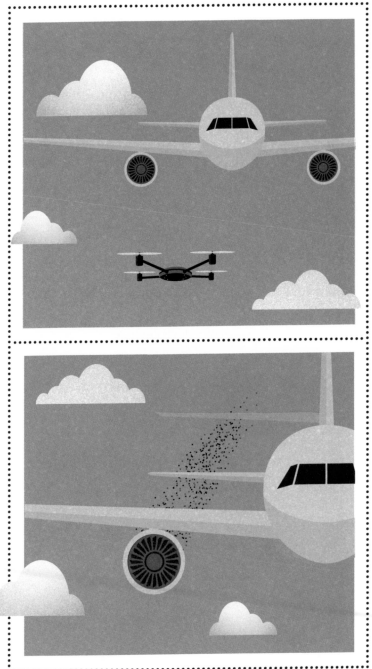

AUTHORITIES

FAA, CAA, & the government

As an aircraft, the regulation of drones falls under the purview of the national Aviation Authority, be that the American FAA (Federal, Aviation Authority), the British CAA (Civil Aviation Authority) or any of the other national institutions.

At least as a drone pilot you've got an advantage over airline pilots—you're fairly unlikely to be passing through multiple control areas during the course of one flight.

AVIATION AUTHORITY

These organizations grew up serving the era of the airliner, and they are not all adapting well to the drone. Only in 2015 did regulation of any kind for drones, or UAVs as they tend to be known, start to emerge in the USA, though other countries have had a below-20kg class for a somewhat longer period.

One of the agencies' duties is to prosecute people who transgress the rules. They're also there to draft new regulations.

AIRSPACE

···

Knowing which territory is marked

Airspace is tightly regulated, especially around airports, so flying your drone safely is a matter of ensuring you're not flying in illegal airspace and contravening guidelines.

The easiest rule to remember is the "vertical ceiling." Drones are limited to 400ft (120m) AGL (Above Ground Level) in the USA, low enough that getting involved in the layers above isn't an issue.

There will also be space around airports, airfields, flying, and gliding clubs, government and military installations, and special events like hot air balloon festivals, which are restricted, either temporarily or permanently.

While some manufacturers include no-fly zones and use GPS to help you avoid straying into airport territory, this won't completely avoid transgressing the rules. It's better to check a regularly updated aviation-mapping site like SkyVector (USA), iFlightPlanner, and SkyDemon Light.

CIVIL LIABILITY

••

Somebody's going to emergency, somebody's going to jail

Like cars, drones are legal, but you can still pilot them illegally. The law generally has two branches—cases brought by police that are called "criminal" matters, and cases people or corporations can bring against each other, called "civil" cases.

Picture this nightmare scenario: a careless drone pilot swoops over a busy road and clips a truck. The truck swerves and jack knifes, and other cars brake. Some hit the truck, others escape. Not everyone survives.

As well as having that on her conscience, the drone pilot now faces a criminal investigation; they're guilty of second-degree murder, or manslaughter as it's called in the UK, which can carry a sentence running into years. Breach of the air regulations might also be a criminal offence.

In the civil courts, the drone pilot is liable for the cost of everything; the truck, the loss to the trucking company because of lost cargo, the insurance companies for all their costs, and, horribly, the value that courts ascribe to human life and limb. Make sure that pilot isn't you!

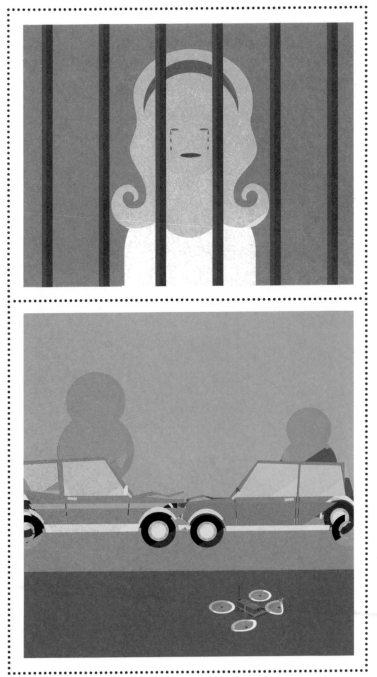

COMMERCIAL

SAFETY CARD

Getting paid?
Then pay up

Recreational use of multicopters is restricted by some fairly common sense rules about where you can fly, but if you're seeking to make a profit—however indirectly—you'll be held to a higher, and more expensive, standard.

In the USA, the talk is of Section 333 exemptions, granted by the FAA while it completes its rules for Small UAS (Unmanned Aerial Systems), while across the sea, aviation authorities are already accrediting various courses for sub-20kg craft.

Inevitably, rules are subject to change even outside the USA, so check your local aviation authority for the latest rules (or a website like your author's own tamesky.com). It looks like rules will certainly make aerial photography and videography easy, but delivery might still face a few roadblocks.

NEWSGATHERING

Our eye in the sky

Hardened broadcast journalists
(and traffic reporters) are among the many
newsgatherers who take to helicopters to get
a new perspective on events, and we've all seen
dramatic aerial video of collapsing regimes or
six-hour traffic jams.

The thing is, "news" tends to happen in places
where you shouldn't fly: crowds, built-up areas,
and so on. But news is important, right? And
they're always asking you to send in your footage,
so it must be cool?

Well, yes and no. In that "yes," it's OK for them to show your footage, but "no" it's not OK that you got it, so they'll be obliged to share where they got the footage from with the authorities. Great for them as they don't need to worry about checking you were obeying the rules, and only a problem for you if you don't want to break the rules in a very public way.

PHOTOGRAPHY ELECTIVE

DRONE CAMERAS

From action cams to professional

If you're buying a drone with photography in mind, then you might find it's easier to pick up a craft with a built-in camera. If, on the other hand, you've already got an action camera, or your drone sees a camera as an optional accessory, then you'll be able to choose your own camera.

The popularity of action cameras as a category, paticularly a certain brand that hints at traveling in a professional direction, has led to a corresponding collection of gimbals and even drones designed specifically around certain camera models, and has meant others are left out in the cold.

The same is also true further up the scale, though at the highest end you can lift cameras with features like remote focusing and optical zoom.

EXPOSURE

The photographer's obsession

From a technical perspective, photography is the art of balancing three key settings: aperture (*f*-stop), shutter speed (fraction of a second) and light sensitivity (ISO).

The aperture is the hole that lets light onto the image sensor; the wider it is open the more light gets onto the sensor, so the shorter the amount of time the shutter needs to be open. A wide aperture also reduces the depth of field, giving blurred backgrounds.

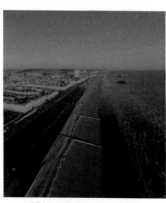

REGULAR ISO (E.G., 200)

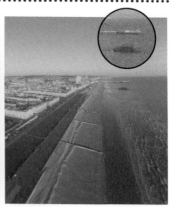

HIGH ISO (E.G., 6400)

ISO allows you to "cheat" this effect by making the camera's sensor more sensitive to light, but the downside is that there is more "noise" (a degradation in image quality as if it were printed on sandpaper).

As a photographer or videographer you need to let the right amount of light in for the camera to "see" the picture correctly—not too bright or too dark. If your camera allows all three settings to be adjusted, you must balance the trade offs in focal range, blur, or noise.

WIDE APERTURE (E.G., *f*/1.4)

SLOWER SHUTTER SPEED
(E.G., 1/4 SECOND)

PRIVACY

Add a camera, add some rules

Cameras can pose problems. Until recently, drones with cameras were de-facto illegal in Holland because the camera's ability to take photos meant it was considered an espionage tool by cold-war legislation, mercifully now repealed.

For the uninitiated, though, once you've established that you're not likely to launch an air strike or engage in terrorism, the next suspicion they'll level at you is that you're a pervert, planning on using your copter to "survey" the girl next door for your own nefarious ends.

The best counter argument, other than the plentiful alternatives to this stratergy, which are much more easily available to any internet user, is to show them just how close you need to be with a typical drone's wide-angle lens, and how noisy a drone is at that range, to see anything much. Demonstrate with a similiarly wide-angle smartphone camera if needs be.

Nevertheless, it is your duty to respect privacy, or get the girl in the bikini's permission (as here).

SMALL WORLDS

Tiny planets

Aerial photography opens up a whole new world (sorry) of photographic trickery. Some people will even sell you balls with several cameras, which you can hang below your drone to capture a complete 360-degree image that can be viewed later using software or virtual reality glasses.

A less expensive solution is to hover in one spot and use the gimbal and/or drone rotation controls to take multiple overlapping images which can be stitched together in software.

Some manufacturers have begun to offer automatic functions to turn the camera to all the necessary positions to capture images in sequence, and even transmit them back to a tablet to be digitally stitched together.

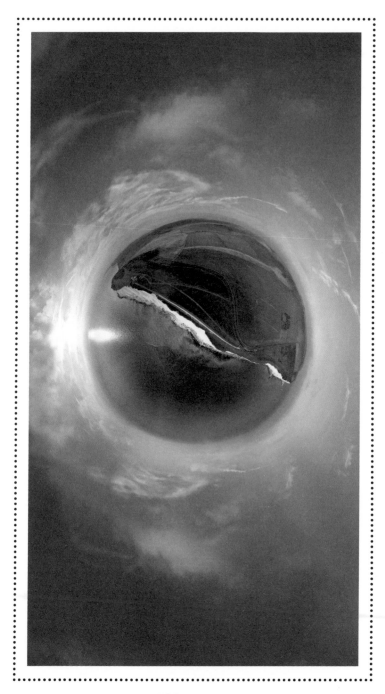

LENS CHOICE

Getting the natural look

Landscape photographers traditionally prefer a wide-angle lens that lets them see a lot of the view at once. The widest kind, fish-eye lenses, are popular with action cameras since they can see so much at once, meaning the extreme sports enthusiasts don't need to worry too much about where the camera is pointed.

Fish-eye lenses are not ideal for aerial photography, but they're commonly attached to lightweight cameras, and weight is crucial, so you might find yourself with pictures that make the Earth look a little curved.

The solution is software. Major image-editing programs have automatic lens correction that detects the camera and provides a perfectly straightened picture, and a number of apps are available for phone and tablet too.

At the top end, of course, pilots can choose interchangeable lenses to get the look they want in the air.

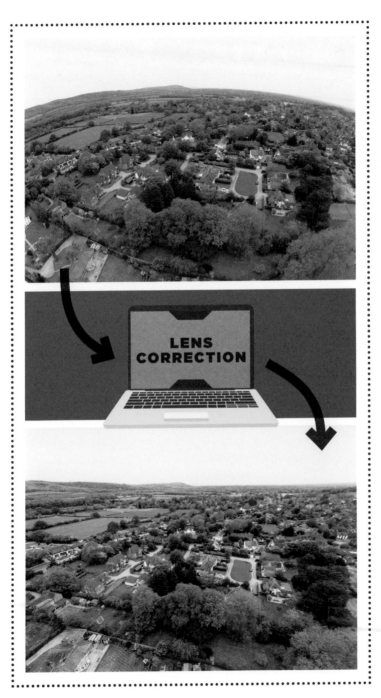

LENS
CORRECTION

151

BATTERY CARE

Tips for a long, healthy life.

They might seem like big dumb bricks, but the battery is one of the crucial technologies that have allowed the world of RC to leave the ground below without resorting to tiny petroleum-gas engines.

That said, while some manufacturers have gone to great care to design smart batteries capable of managing their charge, most power packs require a bit of love.

All LiPo batteries have a maximum charge of 4.2 volts per cell—for example, 3S max out at 12.6V, but have a minimum charge of 3V.

Be sure to land when you feel the power is spent (and you will feel it), as pushing the batteries too much will make them unable to take a proper charge.

CAUTION

Don't leave LiPo batteries in a hot car (or a car that might get hot while you're not there), and make sure that they're not damaged. You might not think it, but a tear in the cell can quickly turn to a fire.

Additionally, you shouldn't store batteries for long at maximum or minimum but at the "nominal" voltage, 3.7V per battery.

Most specialist LiPo chargers have features to help you charge to (or discharge from) this point, and to ensure a "balance" between charge is held in each cell.

Glossary

Accelerometer (ACC) — A component that measures acceleration in a given axis (essentially measuring G force).

Arduino — A low-cost computer/ circuit board with open source (free) software that allows accessories, such as Servos, to be controlled easily. Many flight controllers are built on this system, including ArduCopter.

ARF (also ARTF) — Almost Ready to Fly. Partially pre-built copter kits that might be missing a key element (typically a transmitter).

Autonomous — In the context of drones, a copter that is flying itself, typically by following a pre-programmed flight plan consisting of multiple waypoints.

Barometric Pressure Sensor — A sensor that detects altitude by means of the air pressure.

BEC — Battery Eliminator Circuit. This is a circuit that allows one battery to power multiple devices onboard a copter. For example, it might allow the battery to power the motors at full voltage, as well as smaller motors on a gimbal, or the power needed for FPV. In each case, the circuit will safely step the power down. Although this increases the draw on the main battery, it requires less weight (and volume) than carrying two batteries, and makes charging easier.

Bind — The process of associating a receiver with a transmitter.

BNF — Bind and Fly. A copter that is ready to be bound to a transmitter and flown.

BNUC — The qualification that the CAA in the UK uses to assess a UAV pilot's experience. A cheaper BNUC-S version covers lighter aircraft, but neither is required for hobby use.

Brushless motors — Almost universally adopted in the multicopter world, these powerful motors are more efficient and longer lasting then their brushed predecessors, and less likely to require gearing.

Build — You'll frequently hear pilots referring to their creations by using "build" as a noun, as in: "My build seemed fine until I crashed it into that tree."

CAA — Civil Aviation Authority. The UK body responsible for managing airspace above the country.

Camership — A multicopter built with photography as its primary purpose.

CF — Carbon Fiber. Strong, light building material from which many airframes are at least partially constructed.

CG — Center of Gravity. This is an important point on your craft as it should typically be at the center (to avoid undue load on any one motor). You will often be required to place your flight controller on or near the CG, or at least be able to tell the flight controller how far it is from the CG in setup.

Controller — Often used as shorthand for the pilot's radio-control transmitter (not to be confused with the flight controller).

Drone — A word with a somewhat hijacked meaning (not least by those who refuse to use the word to describe something everyone else would instantly recognize as such). In these pages, it means a multicopter/UAV with no military connotations whatsoever (unless otherwise stated).

ESC — Electronic Speed Controller. A device that sits between the flight controller and the motor to regulate the motor's speed.

Expo — Expo settings change the servo/motor response from a linear line (30% input on the stick, 30% throttle), to an S curve that is flatter (less sensitive) around the center point.

FAA — Federal Aviation Authority. The US authority that manages airspace and sets rules for the use of all aircraft, including multicopters.

FPV — First Person View. Flying using a camera and monitor or video goggles "though the eyes" of the drone.

Gains — Usually pilots are referring to their PID settings.

Gimbal — In the case of drones, this invariably refers to a camera mount that uses motors to stay in the same position relative to the ground, regardless of the copter's movements.

GLONASS — Russian equivalent of GPS.

Gyro — Short for gyroscope.

Gyroscope — A device that measures orientation. Used by the flight controller for leveling the aircraft.

Hobby grade — Another word for drones that are a step up from toys. Encompasses both kit-builds and multicopters, such as the DJI Phantom.

IMU — Inertial Measurement Unit. A combined set of gyroscopes and accelerometers that can determine orientation and stability.

INS — Inertial Navigation System. A method of calculating location based on speed and motion sensors, while GPS is temporarily unavailable.

Intervalometer — A device which can instruct a camera to take a picture every five or ten seconds, for example.

KapteinKUK — A flight control board with a built-in LCD screen. Perfect for modestly priced projects (like the TameSky 1).

LHS — Local Hobby Shop. No more technical than it sounds; a short form that you might see used in discussion forums.

LiPo — Lithium Polymer Battery. Almost every drone uses a LiPo battery, due to its power-to-weight ratio.

LiPo bag — A fire-resistant bag for keeping batteries in. LiPo batteries can degrade and heat up to dangerous temperatures, so LiPo bags should always be used.

LOS — Line of Sight. In almost every operating environment pilots—especially hobbyists—are required to be able to see their copter directly at all times.

mAh — MilliAmp Hours. The capacity of a battery. For example, a 1000 mAh cell (1.0Ah/Amp Hours), would be drained in one hour if a 1 Amp load was placed on it; it would last half an hour with a 2-Amp load; 15 minutes with a 4-Amp load, and so on. In real terms, the greater the capacity of the battery, the longer your flight time.

MAV — Micro Air Vehicle. A small UAV.

MAVLink — A communications protocol used by ArduCopter and ArduPlane autopilots.

Mod — A change from the manufacturer's original design; derived from modification.

MultiWii — A general purpose, open source software project initially developed to allow all kinds of hobbyists to use the sophisticated gyroscopes in the Nintendo Wii controller, which quickly grew to support multirotor aircraft. Now, with those sensors cheap and available, the software is implemented onto flight controller boards that include the sensors.

NAZA — A flight controller produced by DJI for self-build hobbyists. A variant of the NAZA system sits inside the company's popular Phantom 1 and 2 series.

NMEA — The initials for the US National Marine Electronics Association. Crops up in the term "NMEA Sentences," which refers to an ASCII string from a GPS module.

Octocopter — A multicopter with eight props.

Optical Flow Sensor — A sensor that uses a downward facing camera to identify visible textures/features and uses these to measure the speed the drone is traveling over the ground. DJI has made much play of these features, but other craft were using them long before (notably, Parrot's AR.Drone 2).

OSD — On-Screen Display. A way to integrate telemetry data into the video link from a drone, so it can be seen in FPV goggles or on a monitor.

Payload — The amount of weight your vehicle may be able to lift, aside from itself and its batteries.

PIC — Pilot in Control (as opposed to Computer in Control, which would mean autopilot). This is more commonly pro jargon.

PID — Proportional, Integral, and Derivative "gain" settings. These are settings that affect the way the copter responds to control input and external factors (wind). P gain is the amount of correction made to bring your copter level; I gain the amount of time before the flight controller will try harder to make the correction; D gain will work to harmonize the effects of the P and I settings as you are approaching level, to avoid overshooting. The downside is that a high D gain can create a long delay between stick input and action because of the dampening effect.

Pitch — Describes the front/back tilt of the 'copter, which effectively amounts to the forward/backward control on a multicopter.

RC — Radio Controlled. A generic term for all things controlled using a radio controller. The "RC community" encompasses model airplanes, boats, cars, and more.

RTF (Ready to Fly) — A multicopter that is supplied ready to fly, out of the box. There might still be a few settings to adjust, but other than that, you'll be good to go.

RTH (Return to Home) — A flight mode that takes the aircraft back to the point it took off from, where it will land. This is often set up as a fail safe should the copter lose radio connection. Note that it is important to set RTH with an altitude that will clear any nearby obstacles before landing.

RTL (Return to Land) —
See Return to Home.

Roll — The rotation around a point. In an airplane, it would be roll around the fuselage (one wing tips up, the other down); in a multicopter, it is leftward or rightward movement without moving or turning the front (as opposed to yaw/rudder).

Rx — Short for "receiver" or "receive."

Telemetry — Data received from a remote system, typically including information on speed, altitude, battery status, and so on. Many Rx/Tx systems include built-in telemetry systems. Telemetry is taken for granted by pilots of systems, such as the Phantom 3, but it is by no means necessary for flight.

Throttle — Used to increase or decrease the rotation of the props, the throttle is effectively an up/down control.

Toy grade — Hobby retailers like to distinguish between "hobby grade" (good/expensive) and "toy grade" (poor/low-cost) multicopters, but much can be learned from the art of keeping a "toy grade" micro-copter in the air. However, don't expect to be able to replace parts or take quality video with models in this category.

Tx — Short for "transmitter" or "transmit."

UAS — Unmanned Aerial System. A term derived from a military adaptation of UAV, which is meant to better reflect that the craft is just part of a chain, with infrastructure also required on the ground.

UAV — Unmanned Aerial Vehicle. Any aircraft that is flown remotely (though occasionally confused with Unmanned Autonomous Vehicle, which can refer to anything, airborne or not, and isn't usually a civilian term).

Ultrasonic sensor — Used to determine distance from the ground by bouncing soundwaves off it. Only works reliably at distances of approximately 6.5–10ft (2–3m).

VLOS — Visual Line of Sight. *See* LOS.

Waypoint — A specific location in space, defined by a set of coordinates. If you're setting an autonomous flight, you'll typically send the drone to a series of waypoints.

WOT — Wide Open Throttle. 100% throttle, as in: "My sweet copter will shoot up 10 meters a second WOT."

Yaw — Describes the rotation around a central point. On an airplane, the turning effect is provided by the rudder.

Index

THANKS

ACKNOWLEDGMENTS

"Over the years, I've come to regard you as people... I... met."

SECOND TECHNICIAN ARNOLD J. RIMMER

For the existence of this book, I owe a debt of gratitude to everyone at ilex/Octopus who were prepared to imagine that owning a drone didn't mean you couldn't appreciate a nice-looking book, and for that niceness my hat is doffed to illustrator/designer, Anders Hanson. That a book seems a nice idea does not mean it appears from thin air either; without king of the schedules (and iPads*), Frank Gallaugher, this book would have spiraled into chaos. Thanks too to Natalia Price-Cabrera for her magnificent editing skills, Julie Weir for her artistic direction, Pete Hunt for showing me up in the office for flying my drone better than me, and Roly Allen whose fault it is that I write about drones at all. A huge thanks, too, to Jack Nash, drone-pilot extraordinaire.

Outside the office, for keeping me going and tolerating my flying, crashing, soldering, and repeating, boundless thanks and love to Vasiliki, and, of course, my mum, dad, and sister Emily.

*seriously, google him.